Praise for *EX-posed*

"Juxtaposed against violent images of animals and their deaths, Gordon Meade's poems showcase the tortured and unnecessary loss not only of animal life but of animals' joy, culture, and beauty too. Read in succession these poems offer a simple, but scathing account of the numerous ways in which animals' bodies, pride, and homes are destroyed by humans' seemingly insatiable, varied, and violent means of consuming them. Gordon's words strike the tone of sadness we should all be feeling at how much has been lost and the prevalence of our continued violent relations with animals. I'll be churning over these words and images for some time." —**Claudia Hirtenfelder**, host of the Animal Turn Podcast.

"With artful simplicity and heartbreaking persistence, the poems in *EX-posed* march into our hearts like carpenter ants. Their rhythms lay down a drum beat that synchronizes with the thud of our heart, the tap of claws on bars, the drip of blood from a hanging carcass. This is a collection we can complete in a single reading yet the poems within the covers will stay with us forever as a reminder of our humanity and the responsibility that brings. The insistence of each line will beat inside us every time we encounter a nonhuman species, whether behind a fence, inside a cage or on a plate. These poems and the difficult truths that the photographs they accompany illustrate warn us we are animals too and that it's time to end the suffering we're causing our fellow earth-mates." —**Joanna Lilley**, poet & author

"The photographs in *HIDDEN* changed me. I spend much of my time immersed in the atrocities that we humans do to animals, but these photographs made it all hit home a little harder. They're powerful and they're haunting and looking at them is as close as many of us will ever be to looking into the animals in these wretched situations eyes.

I thought that was as real as it got, until I read the poems in Gordon Meade's, *EX-posed*. Until then, I was not aware that it was possible to make me feel more deeply for and think more about the animals in these photographs. Gordon's poems add another layer. A new layer. Instead of seeing the sadness and horrors of these animals' lives, Gordon's poems remind me of the lives that the animals didn't get to live; and for most of them, they didn't get to live them even for an hour.

I'm reminded of what we've taken away from them, of who they are in the world, of their importance, not just to me or to anyone else, but to themselves, for their own sakes. We've striped them bare of everything they

were ever meant to have or be—and then, in most cases, killed them shortly thereafter. Gordon's poems made me look a little longer and a lot harder and remember who these beings were supposed to be. Which also makes me wonder, who are we supposed to be? Because I don't think the answer is a species that commits the atrocities that we witness in this book. I hope we are better than that and I think Gordon's poems might remind us of that as well."—**Elizabeth Novogratz**, Founder and President of Species Unite

"Simple—Striking—Essential. Masterfully, Gordon Meade holds back, saying no more than needs to be said. His portraits of the hidden lives and being of victims of human arrogance and ignorance are raw yet intensely lyrical. A stark accompaniment to the haunting photographs by Jo-Anne McArthur and other activists, throughout the book, pulsing, breathing individuals are telling us: "'I am—I am—I am, and my life matters.'"
—**Teya Brooks Pribac**, PhD, Interdisciplinary Scholar, Artist, and Author of *Enter the Animal*

"These are words that can unravel you, these are words that can remake you."—**Dr. Richard Twine** (he/him), Senior Lecturer in Social Sciences, Department of History, Geography and Social Science (HiGSS), Co-Director of Centre for Human/Animal Studies (CfHAS)

"Having broken new ground in writing about nonhuman animals with *Zoospeak*'s formal experiments, Gordon Meade and Jo-Ann McArthur return with a fresh triumph, *EX-posed*. Deeply ingrained stereotypes, which imagine living animals to be nothing more than resources, toys, garbage, or cute ornaments for 'our' world, are the veils we humans draw over who nonhumans really are and how they actually live and suffer. In collaboration with vivid images from McArthur's multi-photographer project, *HIDDEN*, Meade's poems quietly but relentlessly draw back those veils. Another radical project from a poetic innovator and an indefatigable photojournalist, *EX-posed* will warm your heart and leave you shattered."—**Mandy-Suzanne Wong**, author of *Listen, we all bleed*

"Many of the photographs depict the tragic loss of the animal gaze, especially when eyes look back at us, but the elegies recuperate creaturely embodiment even as death lurks in the shadows. Together the images and poems dramatize that human instrumentalising of animals across national borders, ecological zones, religions and customs is irredeemable."—**Wendy Woodward**, Professor Emerita, Department of English, University of the Western Cape, Cape Town, South Africa

Animal Elegies

Poems by Gordon Meade

Images by Jo-Anne McArthur et. al

Lantern Publishing & Media ● Woodstock & Brooklyn, NY

2022
Lantern Publishing & Media
PO Box 1350
Woodstock, NY 12498
www.lanternpm.org

Cover design by Rebecca Moore.

Printed in the United States of America

Library of Congress Cataloging-in-Publication Data

Names: Meade, Gordon, author. | McArthur, Jo-Anne, photographer.
Title: EX-posed : animal elegies / poems by Gordon Meade ; images by Jo-Anne McArthur et. al.
Description: Woodstock : Lantern Publishing & Media, [2022]
Identifiers: LCCN 2022016344 (print) | LCCN 2022016345 (ebook) | ISBN 9781590566763 (hardback) | ISBN 9781590566770 (epub)
Subjects: LCSH: Animals—Poetry. | BISAC: NATURE / Animal Rights | PHOTOGRAPHY / Photojournalism | LCGFT: Poetry. | Photographs.
Classification: LCC PR6063.E19 E96 2022 (print) | LCC PR6063.E19 (ebook) | DDC 821/.914—dc23/eng/20220521
LC record available at https://lccn.loc.gov/2022016344
LC ebook record available at https://lccn.loc.gov/2022016345

For Wilma and Sophie

CONTENTS

A bird does not sing because it has an answer.
It sings because it has a song.
—A Chinese Proverb

PREFACE:

from *Captive* to *Zoospeak* through *HIDDEN* to *EX-posed*

I first came across the work of the Canadian photographer and animal activist, Jo-Anne McArthur, towards the end of 2016, initially in her book, *We Animals (2013)*, and then in *Captive (2017)*. It was the experience of seeing the images in *Captive* that prompted me to attempt to form a poetic response to Jo-Anne's work. The poems I wrote in response to a number of the images in both *We Animals* and *Captive* were gathered together and published, alongside the images that were their inspiration, in the collection *Zoospeak (2020)*.

In January 2021, Jo-Anne's third book, *HIDDEN: Animals in the Anthropocene*, a collaboration between herself, Keith Wilson, and over forty other contributors, was published. Even more so than with *Captive*, I was once again moved to write something about the disturbing images contained within its covers. Looking through the images in *HIDDEN*, I became aware that another approach to the making of the poems for *EX-posed* would be needed. Although I had found the writing of the poems for *Zoospeak* complicated, on a number of levels the images in *HIDDEN* were, to me, even more upsetting.

Unconsciously, at first, the form that appeared to be most appropriate was a sparse, pared down form of poetry. Once again, I used the first person and the present tense, but incorporated more rhythm and rhyme in the poems. It became my intention to allow the non-human animals, all of whom had found themselves in their own form of death row, the opportunity to utter a few last words which, I hoped, would give them the chance, in a very concentrated space, to say something about their lives, and mythologies, while not avoiding some commentary regarding their present situation. As in *Zoospeak*, the poems in *EX-posed* rely heavily upon the visual images for their initial inspiration. On some level, I see the poems in the new collection in juxtaposition to the images, perhaps in the same way a spoken elegy might be given against the backdrop of a photograph of the deceased.

Once again, I am extremely grateful to Jo-Anne McArthur, and the other photographers who have given me permission to use their images. Without their generosity, and the hard work of Brian Normoyle, and his team at Lantern Publishing & Media, this book would never have come into being.

Gordon Meade
Upper Largo, 2022

FOREWORD
by Jo-Anne McArthur

In photojournalism, humans are the main event. Street photography makes art of sociology. Conflict photography captures political and individual violence. We are visual anthropologists, making images of ourselves.

There is an emerging genre of photography, however, in which non-human animals are not viewed peripherally or relegated to the margins of human stories. In animal photojournalism, animals and their lived experiences are the focus. The primary differentiation of animal photojournalism is that it is not exclusive of any animal, and includes very deliberately those with whom we coexist and yet fail to see. They are the trillions of animals we eat, wear, use for research, entertainment, labour, and in religious and cultural practices.

I've always had a deep concern for animals, as well as a ceaseless shock and sorrow for how we treat them. In my nascent days as a photojournalist, and now as a photo editor and image jurist, I have noticed how animals are portrayed and displayed. They are an appendage, an afterthought, an anecdote. In single images as in photo narratives, this is what I see:

Slaughterhouses—the ground zero of confusion and fear for animals—are about human rights.
Refugees fleeing with their companion animals is about human compassion.
Fishing is about subsistence, or trawling, or overfishing, or oceanic pollution.
Fox hunting is about class and tradition.
Animal sacrifice is about culture and religion.
The last rhinos are about human efforts and failures.
Grazing sheep is about soil erosion.
Cattle in the Amazon is about deforestation, consumer industries like leather and land tenure disputes.
Ranching is about the romanticism of rural life, dust and sunsets.
Roadkill is about the dangers animals pose to drivers.

Animal photojournalism puts the animal story at the centre. My photo agency, We Animals Media, has created a tome of a book called *HIDDEN: Animals in the Anthropocene*, which is the work of forty photographers who have depicted the animal experience. The book demands that we look at the individuals caught in the human world, and its images demand we face their lives, their despondency, their daily tortures, traumas, and deaths.

HIDDEN exposes their lives. *EX-Posed* is a fitting title for this book of poetry, in which Gordon Meade writes unflinchingly about what, and whom, he has seen in *HIDDEN*. Deepening the images, Gordon words are searing. Direct. Painful. Necessary.

An artist's social commentary should always be revelatory. We share our worldview and how we perceive human foibles and dysfunctions. In the case of mine and Gordon's art, we are confrontational and demanding. We insist: *Look. Feel uncomfortable. Don't turn away.* We say *Do something with this.* We ask for nothing less than your compassion for others. In so doing, we plant seeds we hope will germinate. Reducing animal suffering is imperative.

It is thrilling to me that Gordon has written another captivating book inspired by animal photojournalism. As a lifelong devotee of poetry, I'm honoured by what *HIDDEN* compelled in him. With every word and every photograph, the message—our message—about looking, and about what we do to others, becomes more potent.

The final poem in *EX-Posed* leaves me mute, and strengthens my resolve. When I feel this way—both determined yet hopeless—I recall a poem by Shantideva who was an eighth century philosopher and Buddhist monk. I also included this poem in *HIDDEN*. To me, it is a prayer that has transcended centuries and encapsulates my wishes.

May the frightened cease to be afraid
And those bound be freed;
May the powerless find power,
And may people think of benefitting each other.
For as long as space remains,
For as long as sentient beings remain,
Until then may I too remain
To dispel the miseries of the world.

With gratitude to Gordon and to animal photojournalists; thank you for exposing yourselves to the suffering of others, and for making images and texts that in turn expose animal sentience to those of us who need to see. All of this, our desperate cry, our urgent plea.

Jo-Anne McArthur
Animal Photojournalist, Founder of We Animals Media

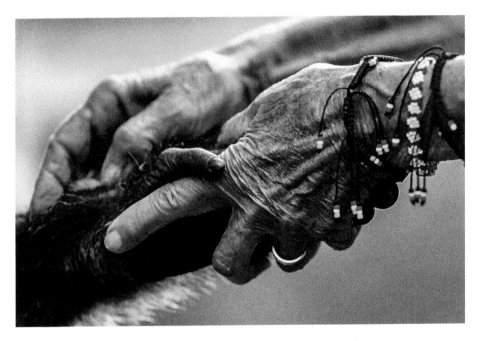

Ora grooming a rescued chimpanzee at Ngamba Island sanctuary. Uganda, 2019. Jo-Anne McArthur / We Animals Media.

IN THE BEGINNING...

We are fur.
We are fin.
We are skin.
We are scale.

We are wing.
We are feather.
We are common.
We are rare.

We are plain.
We are mountain.
We are ocean.
We are mire.

We are earth.
We are wind.
We are water.
We are fire.

I. ANIMAL FARM

*All animals are equal, but some
animals are more equal than others.*
—George Orwell

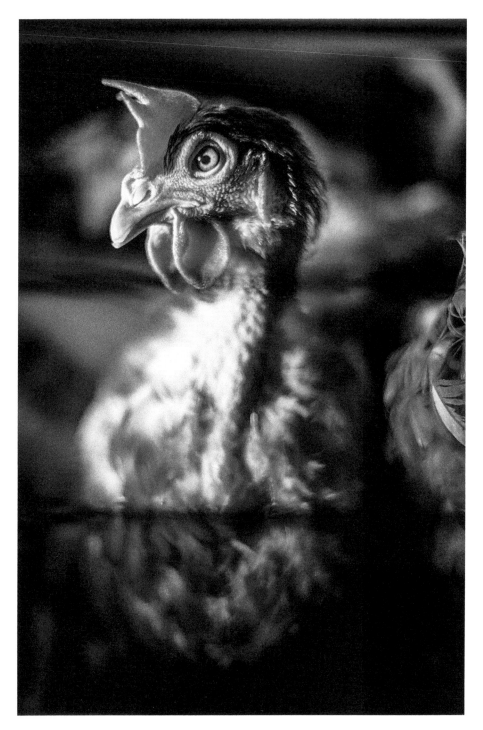

A hen in a cage at a factory farm.
Australia, 2013. Jo-Anne McArthur / We Animals Media.

CHICKEN

I am cluck.
I am strut.
I am wander.
I am roam.

I am beak.
I am feather.
I am wishbone.
I am comb.

I am white.
I am yolk.
I am shell.
I am sky.

I am wing.
I am drumstick.
I am breast.
I am thigh.

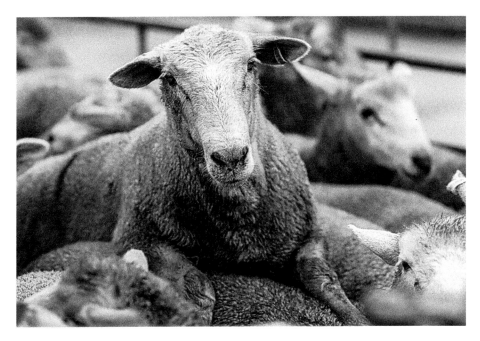

Sheep being loaded onto trucks from the sale yards.
Australia, 2013. Jo-Anne McArthur / We Animals Media.

SHEEP

I am lamb.
I am ram.
I am ewe.
I am fleece.

I am Spring.
I am flock.
I am wool.
I am peace.

I am hearth.
I am home.
I am thought.
I am shorn.

I am born.
I am bred.
I am followed.
I am led.

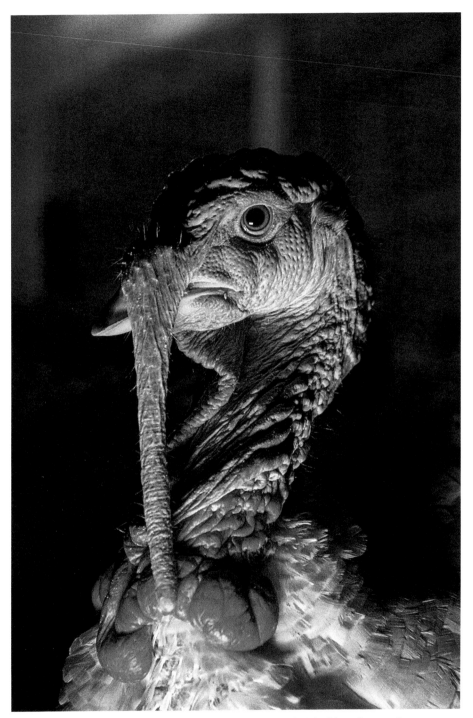

Close-up of an adult male turkeys (tom or gobbler) inside a factory farm.
He has reached slaughter weight and will be sent to slaughter in the morning.
Italy, 2016. Stefano Belacchi / Essere Animali / We Animals Media.

TURKEY

I am Tom.
I am gobble.
I am flap.
I am flight.

I am black.
I am blue.
I am brown.
I am white.

I am Easter
I am Harvest.
I am Christmas.
I am Yule.

I am stuffed.
I am roasted.
I am shredded.
I am pulled.

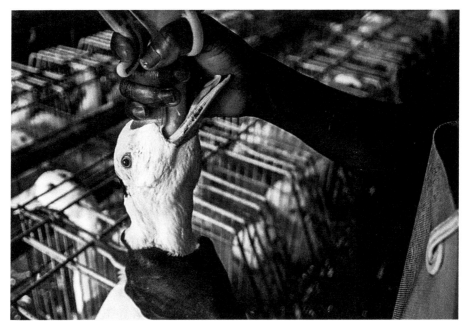

To produce the luxury food item foie gras, ducks and geese are force-fed
to fatten their livers up to ten times their natural size.
Spain, 2011. Luis Tato / HIDDEN / We Animals Media.

GOOSE

I am north.
I am south.
I am flood.
I am drought.

I am water.
I am earth.
I am death.
I am birth.

I am penned.
I am grounded.
I am force fed.
I am gavaged.

I am liver.
I am foie gras.
I am throat-cut.
I am ravaged.

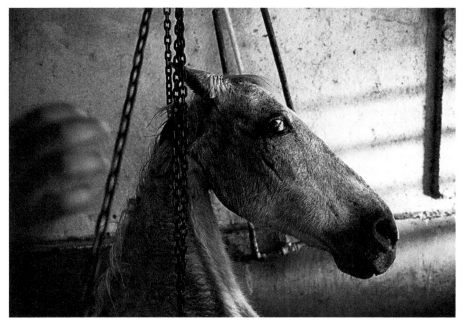

Death approaches. This horse was dragged by a chain around his neck and asphyxiated after being suspended for several minutes. Mexico, 2017. Aitor Garmendia / HIDDEN / Tras los Muros.

HORSE

I am black.
I am yellow.
I am red.
I am white.

I am wind.
I am power.
I am wild.
I am flight.

I am fleet.
I am thunder.
I am storm.
I am bite.

I am chained.
I am hung.
I am smothered.
I am wight.

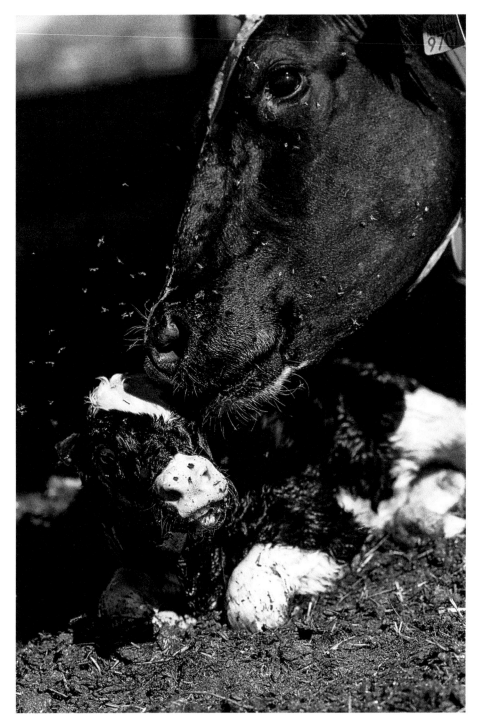

A mother licks the amniotic fluid off her newborn calf.
Spain, 2010. Jo-Anne McArthur / Animal Equality / We Animals Media.

COW

I am mother.
I am mother;
but for far
too many times.

I am son.
I am son;
plucked too early
from the vine.

We are dairy.
We are dairy;
producing
on the hour,

while the milk
of human kindness
keeps on turning;
turning sour.

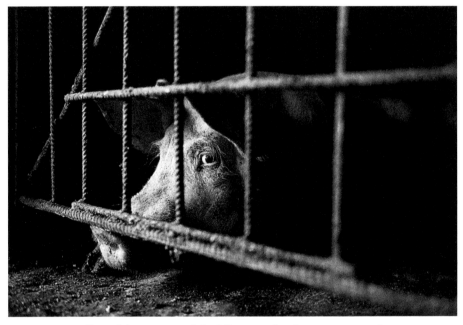

One of the sows, exploited for reproductive purposes and
immobilized in the maternity cage, tries to lay down.
Aitor Garmendia / HIDDEN / Tras los Muros.

PIG

I am black.
I am white.
I am pink.
I am bright.

I am eye.
I am mouth.
I am bristle.
I am snout.

I am Yin.
I am Yang.
I am woman.
I am man.

I am driven.
I am stunned.
I am stuck.
I am done.

II. TO MARKET, TO MARKET

If it hadn't been killed it must have died.
—Anon

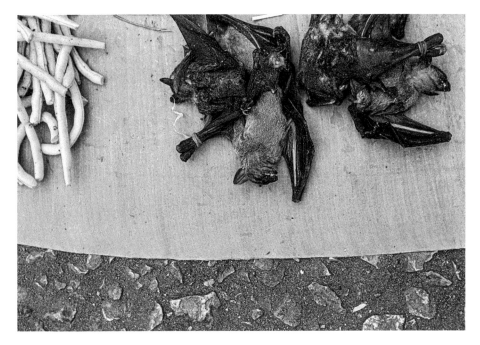

Bats and produce at a market in Luang Prabang.
Lao People's Democratic Republic, 2008. Jo-Anne McArthur / We Animals Media.

BAT

I am echo.
I am flight.
I am blind.
I am sight.

I am tree.
I am cave.
I am dark.
I am grave.

I am east.
I am west.
I am vision.
I am quest.

I am caught.
I am trapped.
I am pinned.
I am wrapped.

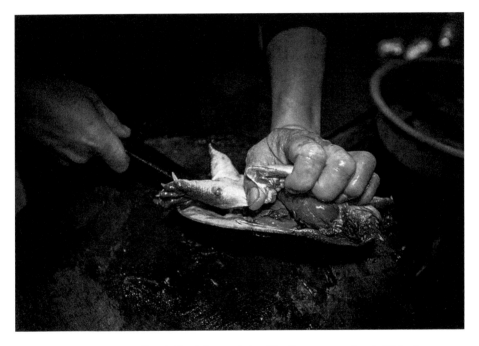

A worker cuts off a shell while turtle is still alive at a market in Taipei.
Taiwan, 2019. Jo-Anne McArthur / We Animals Media.

TURTLE

I am slow.
I am steady.
I am here.
I am now.

I am earth.
I am sky.
I am why.
I am how.

I am inner.
I am outer.
I am patience.
I am home.

I am knifed.
I am severed.
I am gutted.
I am gone.

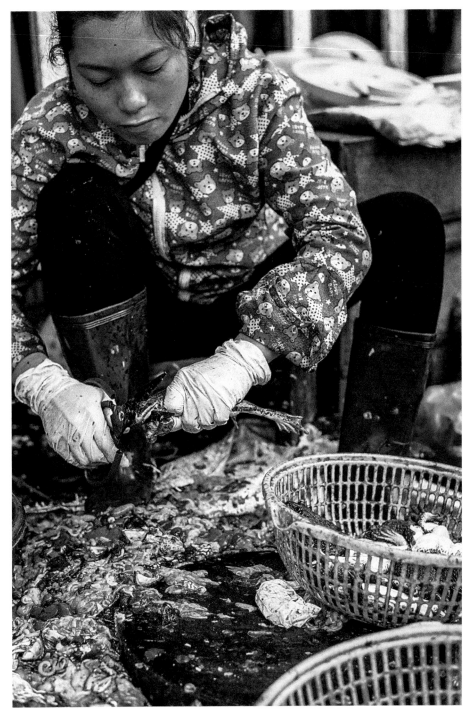

A live frog is decapitated with scissors at a street market as another frog, next in line, watches on.
Vietnam, 2020. Amy Jones / HIDDEN / We Animals Media

FROG

I am tadpole.
I am spawn.
I am mouth.
I am song.

I am pond.
I am stream.
I am marsh.
I am dream.

I am thunder.
I am lightning.
I am sky.
I am rain.

I am paper.
I am scissors.
I am rock.
I am pain.

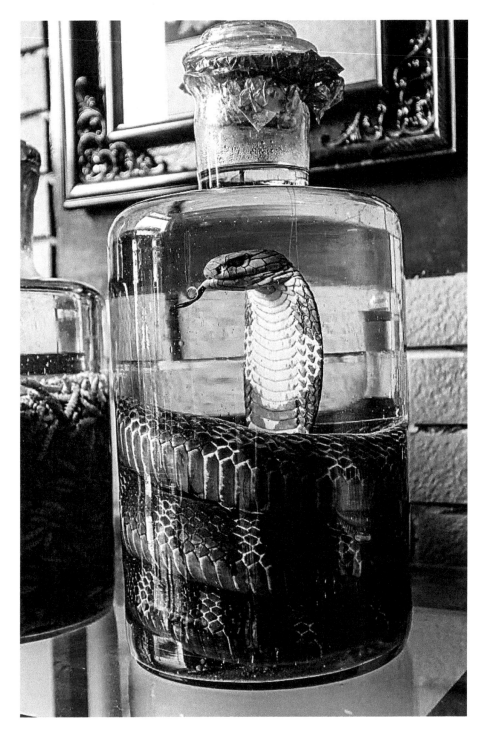

A bottle of snake wine containing a cobra at a snake market in Hanoi.
Vietnam, 2018. Jo-Anne McArthur / We Animals Media.

COBRA

I am fang.
I am venom.
I am strike.
I am spit.

I am danger.
I am poison.
I am wisdom.
I am wit.

I am scale.
I am slither.
I am hood.
I am grass.

I am coiled.
I am pickled.
And entombed
in glass.

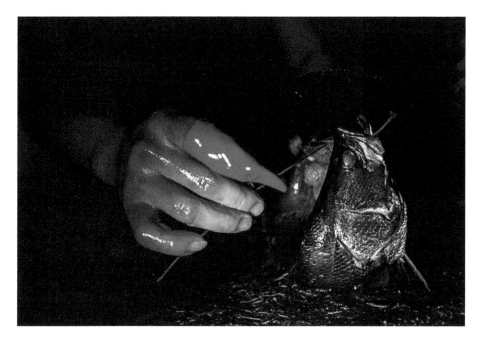

Worker binds fish for sale at a wet market in Taipei.
Taiwan, 2019. Jo-Anne McArthur / We Animals Media.

SEA PERCH

I am sea.
I am wave.
I am salt.
I am cold.

I am deep.
I am shallow.
I am spirit.
I am soul.

I am caught.
I am tethered.
I am crescent.
I am moon.

I am burning.
I am crushed.
I am dying
far too soon.

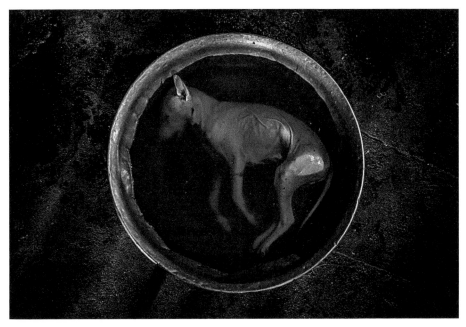

A dog carcass lies in a bucket of water ready to be cooked
at a restaurant in Phnom Penh.
Cambodia, 2019. Aaron Gekoski / HIDDEN / We Animals Media.

DOG

I am missing.
I am stolen.
I am kith.
I am kin.

I am water.
I am blood.
I am flesh.
I am skin.

I am devotion.
I am forgiveness.
I am loyal
to a fault.

I am flayed.
I am butchered.
I am seasoned.
I am salt.

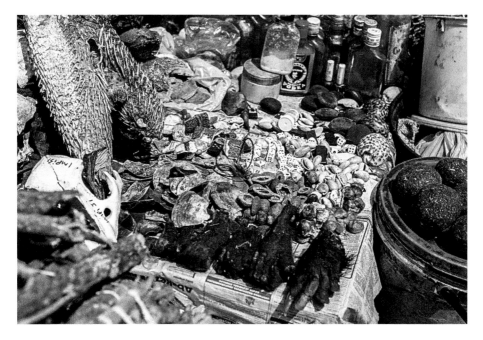

A bear paw, primate hands and other animal parts at a Muti market, Johannesburg. South Africa, 2016. Jo-Anne McArthur / We Animals Media.

BODY PARTS

We are quills.
We are spine.
We are feet.
We are claws.

We are talons.
We are antlers.
We are pelts.
We are paws.

We are heads.
We are tails.
We are legs.
We are bile.

We are scales.
We are horn.
We are rank.
We are vile.

III. WHEN THE BOAT COMES IN

Thou shalt have a fishy on a little dishy.
–William Watson

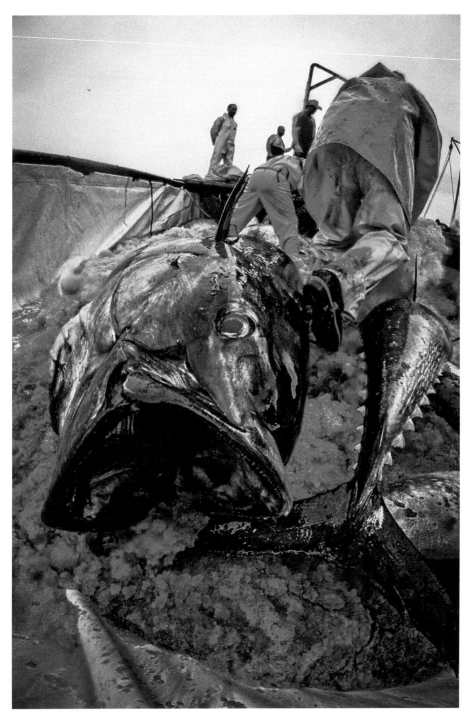

Bluefin tuna are caught in the Mediterranean Sea for the sushi market.
Once hooked on board, they are stabbed and left to suffocate and bleed out.
Italy, 2012. Jonás Amadeo Lucas / HIDDEN / We Animals Media.

TUNA

We are netted.
We are floored.
We are frozen.
We are stored.

We are lifted.
We are raised.
We are senseless.
We are praised.

We are hundreds.
We are thousands.
We are many.
We are few.

We are destined
for consumption.
We are silver.
We are blue.

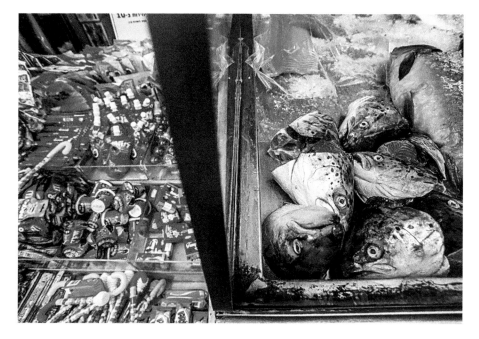

Fish heads and candy on display at a market in Jerusalem.
Israel, 2018. Jo-Anne McArthur / We Animals Media.

SALMON

I am west.
I am wisdom.
I am knowledge
don't you know.

I am fresh.
I am salt.
I am ebb.
I am flow.

I am plenty.
I am endurance.
I am magic.
I am fate.

I am flesh.
I am headless.
I am plastic
on a plate.

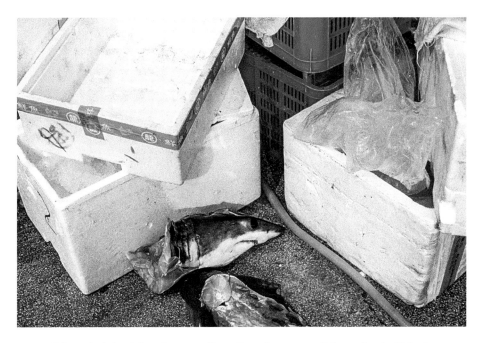

Discarded shark head next to Styrofoam boxes at a fish market in Taipei. Taiwan, 2019. Jo-Anne McArthur / We Animals Media.

SHARK

I am grey.
I am white.
I am dark.
I am light.

I am hunger.
I am motion.
I am reef.
I am ocean.

I am young.
I am old.
I am bought.
I am sold.

I am gaffed.
I am finned.
I am sliced.
I am skinned.

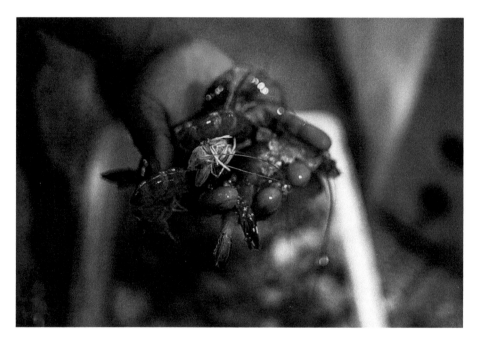

A vendor holds up a handful of dead prawns.
India, 2021. S. Chakrabarti / We Animals Media.

PRAWN

We are wealth.
We are bounty.
We are abundance
gone wrong.

We are sea food.
We are starters.
We are singers
without songs.

We are handled.
We are husked.
We are all.
We are one.

We are boiled.
We are battered.
We are fried.
We are done.

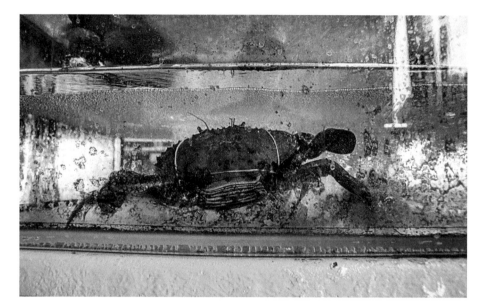

Crab in a tank at a fish farm.
Australia, 2017. Jo-Anne McArthur / We Animals Media.

CRAB

I am hermit.
I am horseshoe.
I am spider.
I am shore.

I am soft.
I am hard.
I am armour.
I am more.

I am ebb.
I am flow.
I am moon.
I am tide.

I am claw.
I am pincer.
I am bound.
I am tied.

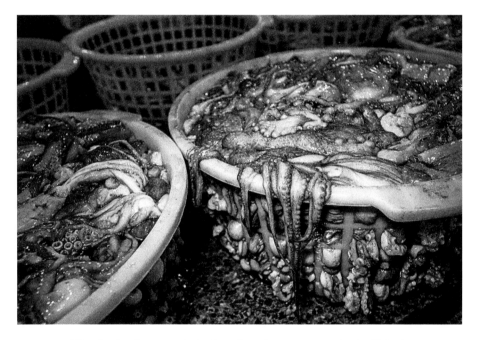

Hundreds of octopus in baskets for sale at a wet market in Taipei. Taiwan, 2019. Jo-Anne McArthur / We Animals Media.

OCTOPUS

I am shape.
I am shift.
I am colour.
I am hidden.

I am float.
I am flow.
I am drift.
I am bidden.

I am ink.
I am quill.
I am psyche.
I am will.

I am arms.
I am legs.
I am poison.
I am dead.

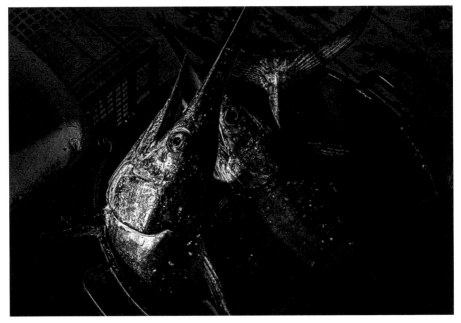

Detail of sword fish onboard the purse seine fishing boat Pandelis II.
Sardines are the targeted species but sword fish are a common by-catch.
Greece, 2020. Selene Magnolia / We Animals Media.

BYCATCH

We are rough.
We are coarse.
We are unwanted.
We are thin.

We are meshed.
We are netted.
We are throwbacks.
We are binned.

We are dolphins.
We are swordfish.
We are seabirds.
We are seals.

We are waste.
We are refuse.
And our fate
has been sealed.

IV. THAT'S ENTERTAINMENT

A baby wailing and stray dog howling.
–Paul Weller

A macaque performs in a popular street show in Jakarta,
known locally as Topeng Monyet (Mask Monkey).
Indonesia. Joan de la Malla / HIDDEN.

MACAQUE

I am beggar.
I am tramp.
I am hobo.
I am scamp.

I am sight.
I am sound.
I am dancer.
I am bound.

I am hatted.
I am masked.
I am suited.
I am trained.

I am hidden.
I am beaten.
I am starved.
I am chained.

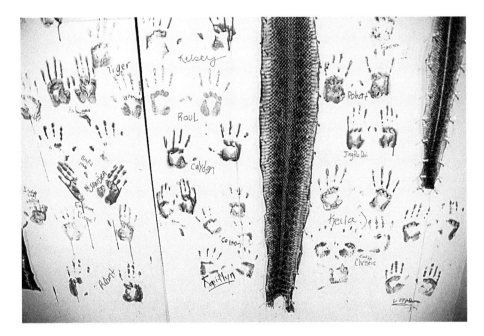

Bloody hand prints and signatures at Texas' Sweetwater Rattlesnake Roundup. USA, 2015. Jo-Anne McArthur / We Animals Media.

RATTLESNAKE

I am body.
I am spirit.
I am earth.
I am fire.

I am time.
I am space.
I am taste.
I'm desire.

I'm revered.
I'm reviled.
I am risen
and I fall.

I'm beheaded.
I am skinned.
I am pinned
to a wall.

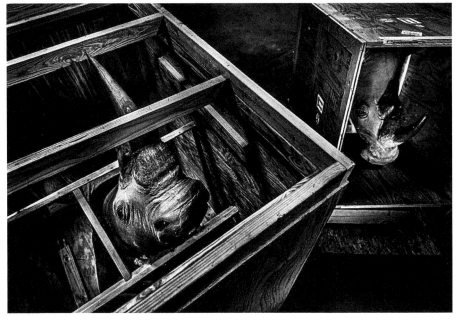

Confiscated white rhinoceros trophies seized by US border officials and stored at a repository housing approximately 1.5 million items from the illegal wildlife trade. USA. Britta Jaschinski / HIDDEN.

WHITE RHINOCEROS

I am skin.
I am armour.
I am hoof.
I am horn.

I am power.
I am muscle.
I am strength.
I am brawn.

I am open.
I am plain.
I am just.
I am crash.

I am box.
I am crate.
I am dust.
I am ash.

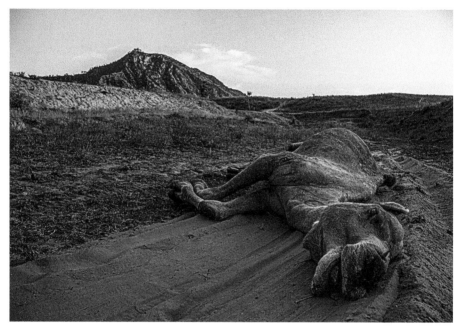

The world famous Pushkar Camel Fair attracts thousands of tourists every year. Afterwards, bodies of unwanted camels are abandoned outside the town. India, 2011. Julie O'Neill / HIDDEN / We Animals Media.

CAMEL

I am sand.
I am dune.
I am desert.
I am ship.

I am lash.
I am lid.
I am nostril.
I am lip.

I am well.
I am water.
I am swallow.
I am swill.

I am loss.
I am left.
I am dumped.
I am still.

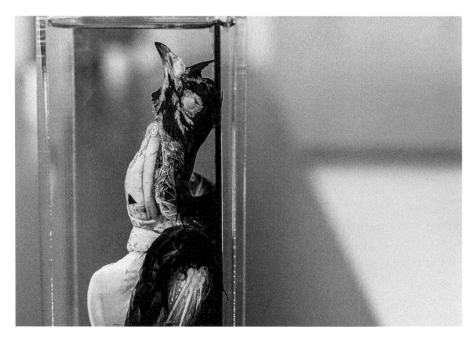

Pigeon at a veterinary school.
Canada, 2007. Jo-Anne McArthur / We Animals Media.

PIGEON

I am London.
I am Venice.
I am Glasgow.
I am Rome.

I am carrier.
I am passenger.
I am racing.
I am home.

I am love.
I am peace.
I am song.
I am crop.

I am bottled.
I am pickled.
I am shelved.
I am naught.

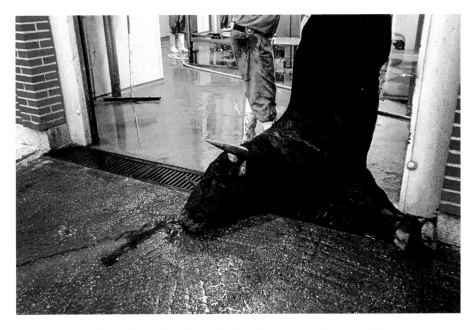

A dying bull is hoisted into the slaughterhouse after the bullfight.
Spain, 2010. Jo-Anne McArthur / We Animals Media.

BULL

I am power.
I am glory.
I am regal.
I am sun.

I am bold.
I am strong.
I am determined.
I am one.

I am fought.
I am defeated.
I am discarded.
I am bled.

I am head
over heels.
I am hanging
by a thread.

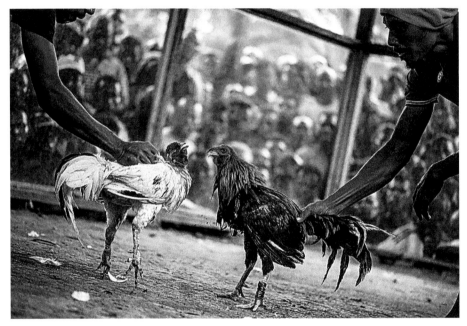

The tradition of cock fighting stretches back thousands of years,
but the result has never changed: a gruesome death.
East Timor, 2017. Aaron Gekoski / HIDDEN / We Animals Media.

COCK-FIGHTING

I am dawn.
I am morn.
I am sun.
I am song.

I am wit.
I am truth.
I am voice.
I am sooth.

I am game.
I am bred.
I am tested.
I am bled.

I am gaffs.
I am spurs.
I am pitted.
I am dead.

V. BLIND FAITH

... a cruel waste, one bitter taste.
—Chase & Status

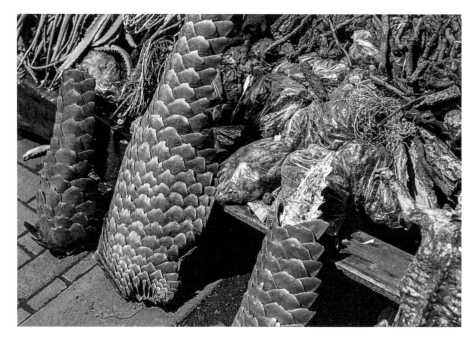

Pangolin tails for sale at a Muti market, Johannesburg.
South Africa, 2016. Jo-Anne McArthur / We Animals Media.

PANGOLIN

I am snout.
I am tongue.
I am ball.
I am scale.

I am black.
I am white.
I am horn.
I am hair.

I am top.
I am tail.
I am shy.
I am still.

I am giant.
I am ground.
I am powder.
I am quill.

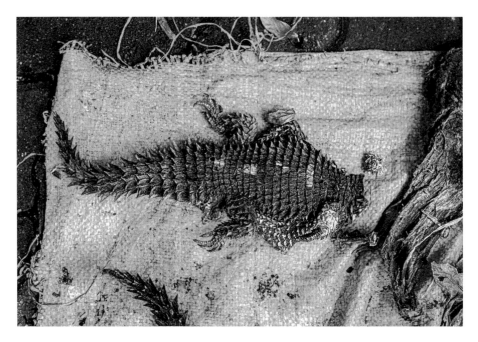

The body of a sungazer at a muti market.
South Africa, 2016. Jo-Anne McArthur / We Animals Media.

SUNGAZER

I am dream.
I am wish.
I am wizard.
I am witch.

I am shade.
I am shadow.
I am scratch.
I am itch.

I am time.
I am space.
I am far.
I am near.

I am sun.
I am fire.
I am hope.
I am fear.

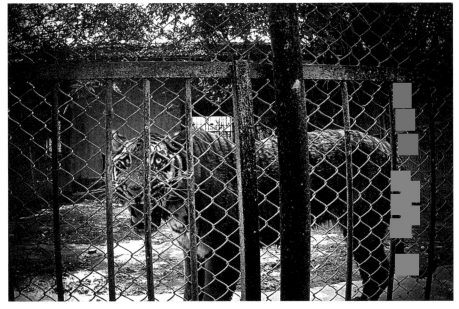

This photo was taken at the world's largest tiger farm in China and it gives you a good idea what the 'LIFE' of a farmed tiger looks like.
China. Britta Jaschinski / HIDDEN.

TIGER

I am burning.
I am bright.
I am strength.
I am light.

I am caged.
I am barred.
I am starving.
I am striped.

I am bile.
I am blood.
I am bone.
I am brain.

I am wine.
I am balm.
I am powder.
I am slain.

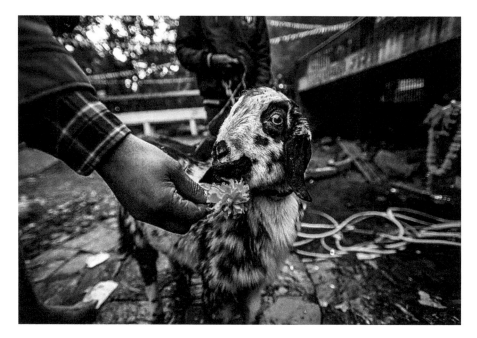

An anointed goat, moments before she is sacrificed at the temple.
Nepal, 2017. Jo-Anne McArthur / We Animals Media.

GOAT

I am dusk.
I am dawn.
I am mountain.
I am lawn.

I am hoof.
I am horn.
I am fleece.
I am shorn.

I am golden.
I am Pan.
I am devil.
I am man.

I am petal.
I am bud.
I am water.
I am blood.

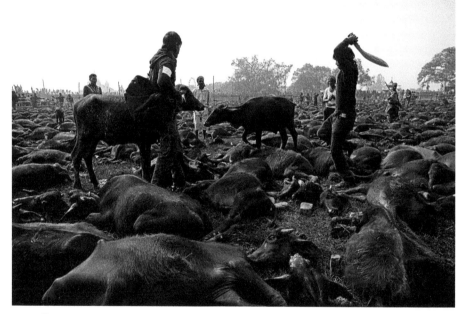

Devotees behead buffaloes during a mass sacrificial killing at the Gadhimai festival, held every five years to honour the Hindu goddess of power. Nepal. Kuni Takahashi / HIDDEN.

BUFFALO

I am marrow.
I am tongue.
I am spirit.
I am sun.

I am mud.
I am earth.
I am humble.
I am wealth.

I am prayer.
I am smoke.
I am sacred.
I am yoke.

I am herded.
I am watered.
And for gods
I am slaughtered.

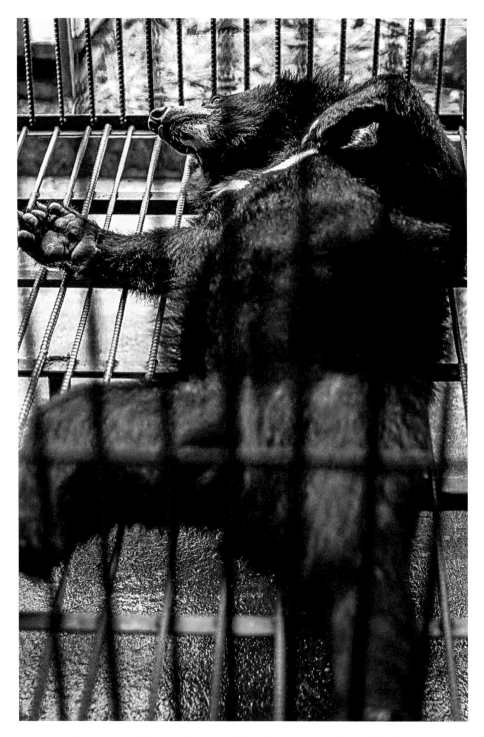

A moon bear lying on their back in a bare cage at a bear bile farm.
Lao People's Democratic Republic, 2008. Jo-Anne McArthur / We Animals Media.

MOON BEAR

I am fruit.
I am nut.
I am honey.
I am claw.

I am gall.
I am wounded.
I am bile.
I am maw.

I am milked.
I am toothless.
I am broken.
I am blind.

I am caged.
I am tortured.
I am out
of my mind.

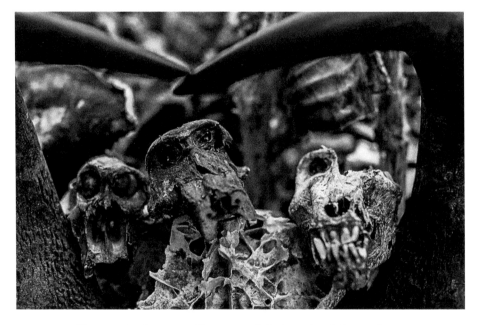

Skins, scales, horns and bones at a Muti market, Johannesburg.
South Africa, 2016. Jo-Anne McArthur / We Animals Media.

VOODOO

I am free.
I am caught.
I am smiling.
I am not.

I am bird.
I am beast.
I am famine.
I am feast.

I am feather.
I am soil.
I am candle.
I am oil.

I am eyeless.
I can see.
I am you.
I am me.

VI. FASHION

Zip me up, it can't be wrong.
–Lady Gaga

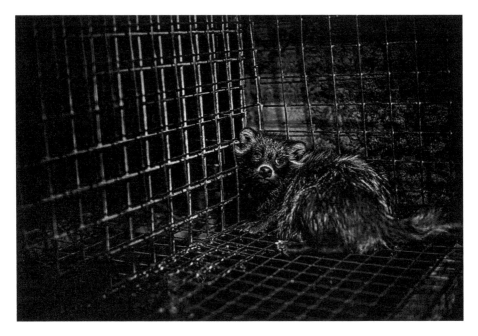

A young racoon dog in a fur farm cage.
2012. Jo-Anne McArthur / The Ghosts In Our Machine / We Animals Media.

RACCOON DOG

I am outlaw.
I am bandit.
I am robber.
I am hood.

I am sneakthief.
I am locksmith.
I am bad.
I am good.

I am watcher.
I am crafty.
I am always
on the go.

I am masked.
I am caged.
I am folly.
I am faux.

Alligators raised for meat.
2019. Jo-Anne McArthur / We Animals Media.

ALLIGATOR

I am green.
I am brown.
I am grey.
I am black.

I am belt.
I am bag.
I am this.
I am that.

I am sight.
I am sound.
I am touch.
I am smell.

I am eyes.
I am teeth.
I am tears.
I am hell.

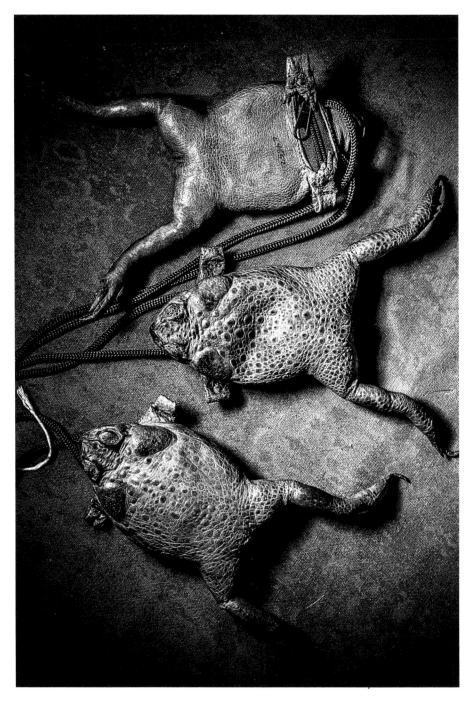

This year's accessory. Confiscated purses made from cane toads.
USA. Britta Jaschinkski / HIDDEN.

CANE TOAD

I am croak.
I am grumble.
I am hunger.
I am heart.

I am mouth.
I am dry.
I am rough.
I am wart.

I am jewel.
I am toxic.
I am poison.
I am curse.

I am flattened.
I am zippered.
I am wallet.
I am purse.

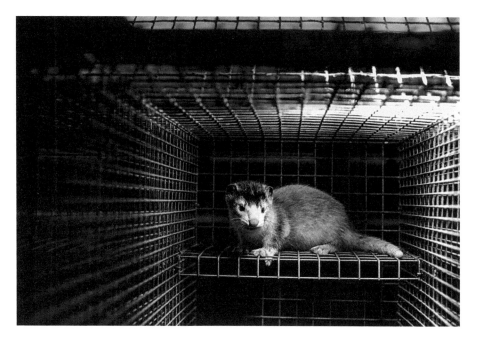

Mink at a fur farm.
Sweden, 2010. Jo-Anne McArthur / Djurrattsalliansen / We Animals Media.

MINK

I am shawl.
I am eyelash.
I am cape.
I am coat.

I am Harrods.
I am Hermes.
I am Herno.
I am Ho.

I am dream.
I am vision.
I am play.
I am fight.

I am Covid.
I am culled.
I am gassed.
I ignite.

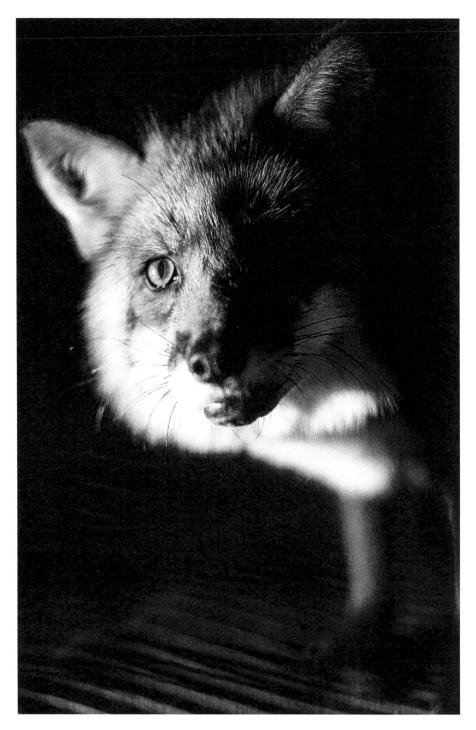

A red fox in a fur farm.
Canada, 2014. Jo-Anne McArthur / #MakeFurHistory / We Animals Media.

FOX

I am dog.
I am vixen.
I am witch.
I am wiccan.

I am quick.
I am brown.
I am lost.
I am found.

I am fur.
I am farm.
I am henhouse.
I am harm.

I am swift.
I am fast.
I am electric.
I am gas.

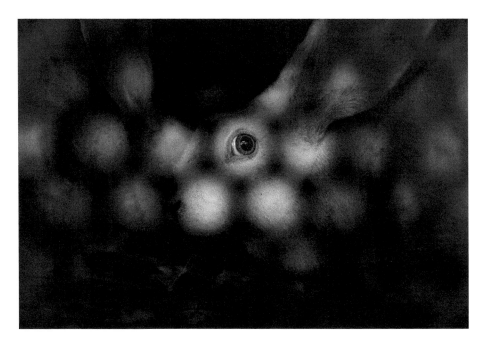

Rabbits arrive in containers that are stacked in the slaughter area.
Aitor Garmendia / HIDDEN / Tras los Muros.

RABBIT

I am look.
I am leap.
I am stop.
I am go.

I am zip.
I am zag.
I am fast.
I am slow.

I am fear.
I am tremor.
I am panic.
I am weep.

I am dread.
I am dying.
I am slumber.
I am sleep.

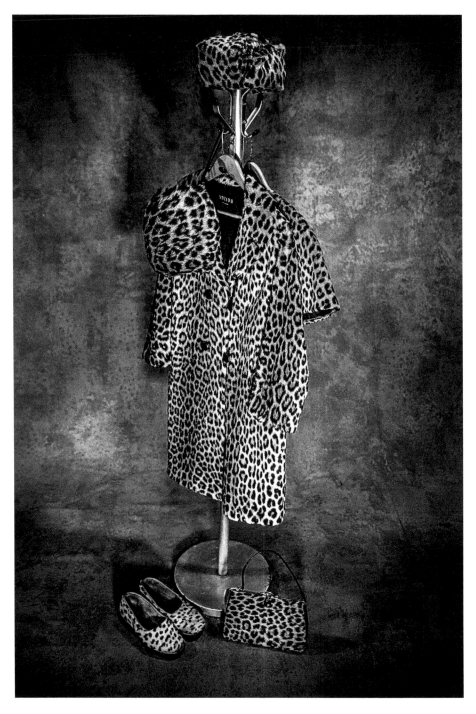

An estimated 20 leopards were killed to make these confiscated couture fashion items. USA. Britta Jaschinski / HIDDEN.

LEOPARD

I am sun.
I am midnight.
I am murmur.
I am roar.

I am smoke.
I am mirror.
I am heart.
I am soul.

I am cloak.
I am dagger.
I am jungle.
I am cat.

I am coat.
I am handbag.
I am shoe.
I am hat.

VII. NO SMOKE WITHOUT FIRE

Such a grey coloured nightmare.
–Andy Powell

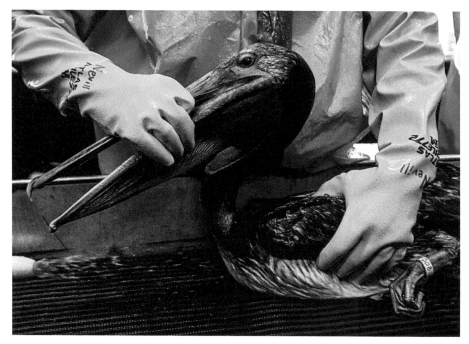

Tri-State staff member Heather Nevill hold a newly de-oiled
brown pelican during the final rinse.
USA, 2010. Jo-Anne McArthur / We Animals Media.

PELICAN

I am poise.
I am grace.
I am love.
I am sick.

I am beak.
I am belly.
I am crude.
I am slick.

I am bill.
I am breast.
I am lead.
I am gold.

I am oil.
I am tar.
I am feather.
I am cold.

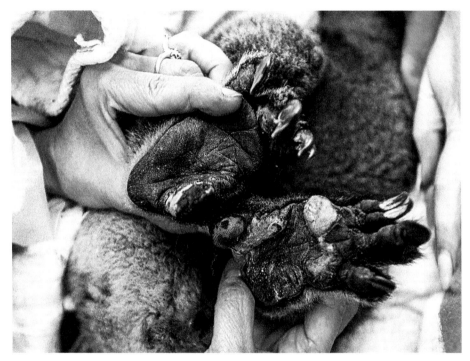

Burned koalas are darted with a sedative, then captured and lowered from the tree for veterinary care. They will later be released into a surviving forest. Australia, 2020. Jo-Anne McArthur / We Animals Media.

KOALA

I am sleep.
I am slumber.
I am snooze.
I am dream.

I am leaf.
I am tree.
I am all
that I seem.

I am calm.
I am flow.
I am settled.
I am slow.

I am singed.
I am scorched.
I am burnt.
I am torched.

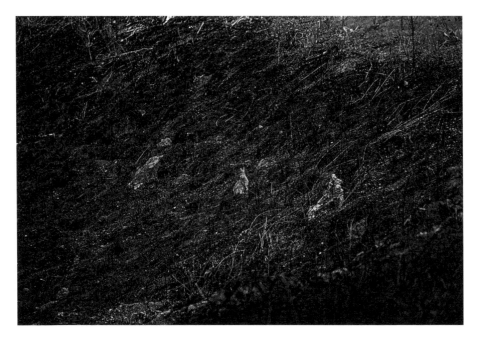

A wild hare traverses a burned landscape.
Australia, 2020. Jo-Anne McArthur / We Animals Media.

HARE

I am hop.
I am skip.
I am jump.
I am dash.

I am fire.
I am fear.
I am lightning
I am flash.

I am field.
I am forest.
I am form.
I am plain.

I am ear.
I am shoulder.
I am burn.
I am flame.

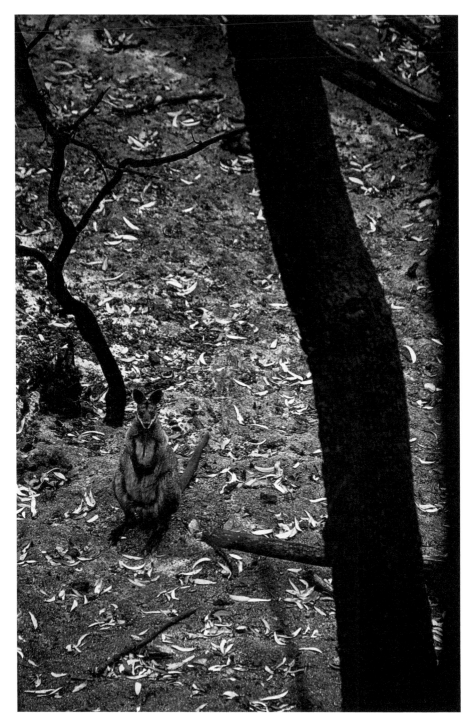

A lone wallaby foraging for food in a burned forest outside Mallacoota.
Australia, 2020. Jo-Anne McArthur / We Animals Media.

WALLABY

I am bush.
I am scrub.
I am rock.
I am tree.

I am judge.
I am jury.
I am guilty.
I am free.

I am drum.
I am rattle.
I am staff.
I am law.

I am body.
I am spirit.
I am charred.
I am raw.

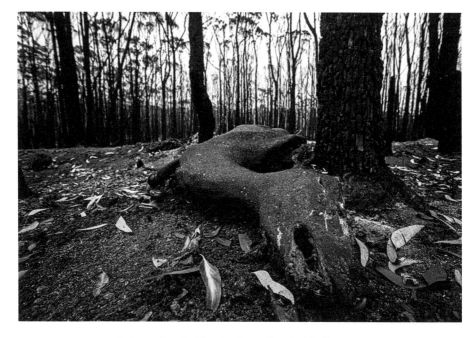

A deer who died in the forest fires in Mallacoota.
Australia, 2020. Jo-Anne McArthur / We Animals Media.

DEER

I am doe.
I am fawn.
I am stag.
I am tine.

I am truth.
I am beauty.
I am heart.
I am mind.

I am hoof.
I am swift.
I am will
o' the wisp.

I am dark.
I am light.
I am burnt
to a crisp.

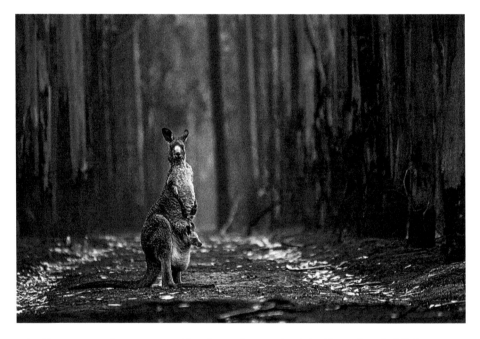

An Eastern grey kangaroo and her joey who survived the forest fires in Mallacoota. Australia, 2020. Jo-Anne McArthur / We Animals Media.

KANGAROO

We are Jill.
We are Joey.
We are leap.
We are bound.

We are dream.
We are nightmare.
We are lost.
We are found.

We are big foot.
We are long tail.
We are spirit.
We are land.

We are grey.
We are tinder.
We are lit
by your hand.

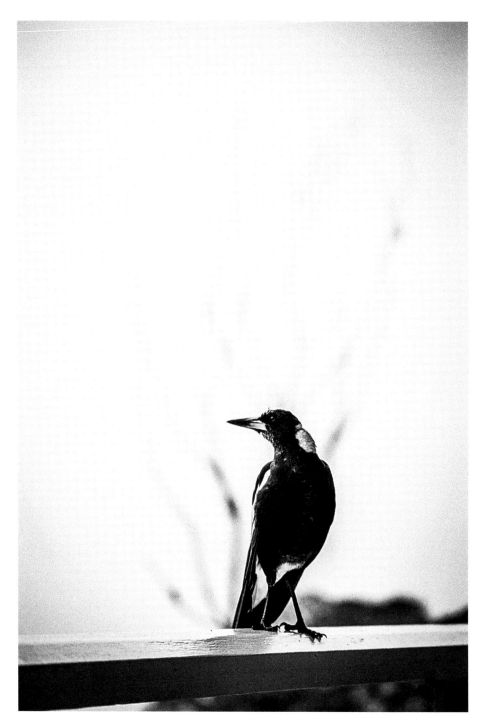

A magpie in a smoky landscape.
Australia, 2020. Jo-Anne McArthur / We Animals Media.

MAGPIE

I am sorrow.
I am joy.
I am girl.
I am boy.

I am silver.
I am gold.
I'm a secret
I am told.

I'm a wish.
I'm a kiss
I'm a bird
you cannot miss.

I'm a feather.
I'm an eye.
I am wind
and I fly.

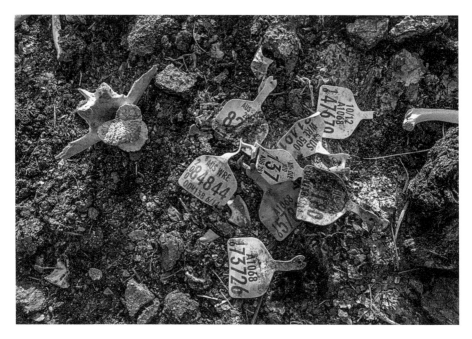

Ear tags and bones next to a quarantine site.
Israel, 2018. Jo-Anne McArthur / Israel Against Live Shipments / We Animals Media.

AT THE END. . .

We are branded.
We are numbered.
We are barcodes.
We are tags.

We are shackled.
We are prodded.
We are driven.
We are dragged.

We are slashed.
We are clubbed.
We are bludgeoned.
We are stunned.

We are skinned.
We are gutted.
We are drawn.
We are hung.

ACKNOWLEDGMENTS

Some of the poems have appeared in the following journals, magazines, anthologies, blogs, and podcasts :
The Animal Turn, The Deal With Animals, The Earth Is Our Home, The Lake, Live Encounters, The Ofi Press, Otherwise Engaged Literature and Arts Journal, pFITE: Poetry & Folk Music in the Environment, and *Species Unite*.

Gordon Meade acknowledges the support of Creative Scotland towards the writing of *EX-Posed: Animal Elegies*.

ABOUT WE ANIMALS MEDIA

We Animals Media (WAM) brings visibility to hidden animals through compelling photo and videojournalism. As the world's leading animal photojournalism agency, it is our mission to document the stories of animals in the human environment—those used for food, fashion, entertainment, and experimentation—and to connect those stories to the individuals and organizations who can amplify their reach.

Our growing network of award-winning photographers and videographers extends throughout the world, capturing images from a broad and diverse spectrum of animal industries. Together, we have created the world's most comprehensive collection of animal photojournalism. This globally accessible resource is made available for free to anyone working to inspire compassion, conversation and change.

weanimalsmedia.org

WE ANIMALS

MEDIA

ABOUT THE PHOTOGRAPHERS

AARON GEKOSKI

Aaron Gekoski is an environmental photojournalist and film-maker specializing in human-animal conflict. His photographs have won numerous awards, including in categories at the Natural History Museum's Wildlife Photographer of the Year competition and Nature Photographer of the Year. As a film-maker, he produces and is the presenter of broadcast documentaries focused on the exotic pet trade and wildlife tourism industry. Aaron is founder of Raise the Red Flag, a global campaign in partnership with the Born Free Foundation that calls out cruel wildlife tourism attractions. As a presenter, he has fronted numerous programs on conservation for major channels such as Smithsonian and Discovery.

www.aarongekoski.com

AITOR GARMENDIA

In the late 1990s, Aitor Garmendia lived in England among people who were actively involved in the animal liberation movement. This experience had a great impact on his life, so he decided to take a side and join his colleagues. "Animals are victims of unlimited violence and oppression in every society," he says. "History teaches us that the first step to stop an injustice is to recognise it and make it visible." Aitor's contribution to that visibility is Tras los Muros (Behind the Walls), an online photography and audiovisual platform focusing mostly on animals raised in factory farms and sent to slaughter, as well as captive animals in

zoos, aquaria, or used in bull fights and other entertainment. His images have been published widely by Spanish-speaking media sites, including El Mundo, Vice, Diario and La Marea.

www.aitorgarmendia.com

AMY JONES

 Amy Jones is the photographer behind Moving Animals, a photojournalism and media project she co-founded with her partner Paul Healey in 2018. Since then, Amy and Paul have worked on the ground to document everything from slaughterhouses to zoos across seven different countries, combining photography, video and journalism to tell animals' stories in mainstream media. Amy's visuals and stories have been published in over 150 publications worldwide including The Guardian and The Independent. After graduating with a degree in Creative Writing and Literature in 2015, she spent the following years producing visual media for People for the Ethical Treatment of Animals (PETA) UK. By editing PETA's undercover investigations, Amy saw first-hand the impact such visuals have on changing people's mindsets towards animals. She hopes that her work allows others to look through a different lens: "one which views animals as individuals, rather than as commodities or property."

www.movinganimals.org

BRITTA JASCHINSKI

German photographer Britta Jaschinski moved to the United Kingdom in the 1990s to study photography, and is currently based in London. Known for her unique style of photojournalism, Britta is the winner of numerous awards, including European Wildlife Photographer of the Year (twice), Photojournalist of the Year in the Wildlife Photographer of the Year competition and the Grand Prize Winner of America's Big Picture Natural World Photography contest. Her investigative images and multimedia productions about the wildlife trade are hard-hitting, yet also hauntingly beautiful and always inspiring. Britta's work has been published by Geo, National Geographic, Stern, Spiegel, The Guardian and WWF Media, and her highly collectable photos are exhibited in galleries and art fairs across the globe. She is the co-founder of Photographers Against Wildlife Crime™, an international group of photographers who have joined forces to use their iconic images to help bring an end to the illegal wildlife trade in our lifetime.

www.brittaphotography.com

JOAN DE LA MALLA

Based in Barcelona, Joan de la Malla is a biologist and photographer who focuses on conservation, nature and the environment. His photographs have been exhibited internationally and recognised in some of the world's most prestigious photo competitions, including the Wildlife Photographer of the Year, European Wildlife Photographer of the Year and the Sony World Photography Awards. As well as documenting conservation stories, Joan gives talks and workshops related to photography and its application in science and conservation at festivals, symposiums and universities around the world. He is a fellow of the International League of Conservation Photographers and a

contributing photographer to the award-winning Photographers Against Wildlife Crime™ initiative.

www.joandelamalla.com

JO-ANNE MCARTHUR

 Jo-Anne McArthur is an award-winning photo-journalist, sought-after speaker, photo editor, and the founder of We Animals Media. She has visited over sixty countries to document our complex relationship with animals. She is the author of three books: *We Animals* (2014), *Captive* (2017), and *HIDDEN: Animals in the Anthropocene* (2020), and is the subject of Canadian filmmaker Liz Marshall's acclaimed Canadian documentary, *The Ghosts in Our Machine.* Jo-Anne's photographs have received accolades from Wildlife Photographer of the Year, Nature Photographer of the Year, Big Picture, AEFONA, Picture of the Year International, the Global Peace Award, and others. In 2020, Jo-Anne was thrilled to be a member of the jury for World Press Photo. She hails from Toronto, Canada.

www.weanimalsmedia.org

JONÁS AMADEO LUCAS

 Jonás Amadeo Lucas has been helping animals in different fields and areas for more than ten years, conducting rescues and investigations in over 30 countries. He has been an investigative photographer for Animal Equality, PETA, Animal Angels and the Parliament of the European Union, with publication in National Geographic, The Times, and other international media. Jon has an MBA in Business Management and a Masters in International Trade, and founded the first animal sanctuary in Spain: El Hogar ProVegan. He is currently the director of

the ProVegan Foundation in Spain, and acts as a consultant for different initiatives around the world.

JULIE O'NEILL

 Inspired by the power of photography, Julie O'Neill uses her camera to expose the exploitation of animals around the world. Since receiving a bachelor of photography in 2003, she has documented the endless suffering of animals of all species in a wide variety of circumstances. To counterbalance the pain she has witnessed, she has volunteered with many organisations that rescue animals and work to change people's hearts and minds. Julie and her family have recently purchased a large piece of forest in Canada, where, for decades, animals were hunted and killed. Now, she says, "this land has been transformed into a place of protection, refuge and peace for animals and humans alike."

@PhotographyforaCompassionateWorld;
www.facebook.com/Photography-for-a-Compassionate-World-142595195804818/

KUNI TAKAHASHI

 Originally from Sendai, Japan, Kuni Takahashi came to the United States to study photojournalism at the Maine Photo Workshops, the New England School of Photography in Boston and the Eddie Adams Workshop in New York. He was a staff photographer for the Chicago Tribune and Boston Herald before relocating to India in 2009, where he spent seven years covering stories in the South Asia region. His assignments have taken him to many war-torn countries, including Iraq, Afghanistan, Liberia, Libya and Somalia. Kuni's photographs have been awarded in the World Press Photo and Pictures of the Year International (POYi), as well as many

other competitions. He has published seven books in Japan, including *Liberia*, about the children of the civil war, *Tsunami*, which focused on the survivors of Japan's 2011 disaster, and *Iraq*, a documentary of life in the wake of America's 2003 invasion.

www.kunitakahashi.com

LUIS TATO

 Luis Tato is a photojournalist based in Nairobi, Kenya. He began his visual education studying different drawing and painting techniques and later received a degree in audiovisual communication. His photography career began while covering Spain's financial crisis for print media, news agencies and several NGOs. Since then, Luis has been a regular contributor to the Spanish newspaper La Vanguardia, while combining his work as a wire photographer covering East Africa for Agence France-Presse. His work has been published in numerous international titles, including The New York Times, The Washington Post, USA Today, The Guardian, Financial Times, National Geographic, Der Spiegel, Die Welt, El País and El Mundo. His awards include first place prizes from Pictures of the Year International (POYI) and The Andrei Stenin International Press Photo Award.

www.luistatophoto.com

S. CHAKRABARTI

S. Chakrabarti is a freelance media professional, focussing on stories of wildlife, conservation and communities, based in India. As a filmmaker, photographer and writer, her work has been published and exhibited in both national and international platforms and events. She is a member of Her Wild Vision Initiative and has produced films, photo essays and articles for Vice, Mongabay, WWF-India, Round Glass Sustain and Nature in Focus, among others.

SELENE MAGNOLIA

Selene Magnolia is a freelance photojournalist and investigator. With a background in grassroots activism, her work spans issues relating to social justice, anthropology, human rights, feminism, animals, the environment and food production. Selene was raised in the Italian Dolomites and now lives between London, where she studied at the British Academy of Photography, and Berlin. Her belief in research, 'slow journalism' and an ethos of political participation, informs her approach to documentary projects, and she is also involved with direct action groups defending solidarity. Photography and investigative work are, she says, "a political tool to spread awareness and to promote change."

www.seleneenamagnolia.com

STEFANO BELACCHI

 Stefano Belacchi was 20 and a politically active student when he started taking part in animal rights campaigns in Italy. After a few years of local campaigns against fur, vivisection and other actions, he co-founded the animal rights group, Essere Animali (Being Animals). Stefano has been working with them for several years, participating as a photographer in their investigations. In recent years, he has also worked with Animal Equality on investigations into chicken farms in Italy, and with Aussie Farms on the documentary film about animal exploitation in Australia, *Dominion*. In 2017, with the philosopher Benedetta Piazzesi, Stefano published Un Incontro Mancato (A Missed Meeting), an essay about animal rights photo-reporting. Stefano also works as a hiking guide in the forests and mountains of central and northern Italy. In his spare time, he enjoys rock climbing around Italy.

www.instagram.com/stefanobelacchi

ABOUT THE AUTHOR

GORDON MEADE is a Scottish poet based in the East Neuk of Fife. He has been the Creative Writing Fellow at the Duncan of Jordanstone College of Art, and the Royal Literary Fund Writing Fellow at the University of Dundee, and has read from his work throughout the United Kingdom, Belgium, Germany, Ireland, and Luxembourg. He is the author of eleven other collections of poetry, including *In Transit* (Enthusiastic Press 2022), *Zoospeak* (Enthusiastic Press 2020), *The Year of the Crab* (Cultured Llama Publishing 2017), *Les Animots: A Human Bestiary* (Cultured Llama Publishing 2015), and *Sounds of the Real World* (Cultured Llama Publishing 2013).

ABOUT THE PUBLISHER

LANTERN PUBLISHING & MEDIA was founded in 2020 to follow and expand on the legacy of Lantern Books—a publishing company started in 1999 on the principles of living with a greater depth and commitment to the preservation of the natural world. Like its predecessor, Lantern Publishing & Media produces books on animal advocacy, veganism, religion, social justice, humane education, psychology, family therapy, and recovery. Lantern is dedicated to printing in the United States on recycled paper and saving resources in our day-to-day operations. Our titles are also available as ebooks and audiobooks.

To catch up on Lantern's publishing program, visit us at www.lanternpm.org.

 facebook.com/lanternpm
instagram.com/lanternpm
twitter.com/lanternpm